MW01014327

hi-fi's & hi-balls

the golden age of the american bachelor

steven guarnaccia and bob sloan

design by susan hochbaum

principal photography by pete mcarthur

CHRONICLE BOOKS

SAN FRANCISCO

to susan and randi,

the only people worth giving up

the bachelor life for, and

to uncle rich and uncle jack,

who were there.

Copyright © 1997 by Steven Guarnaccia and Bob Sloan.
All rights reserved. No part of this book may be reproduced
in any form without written permission from the publisher.

Library of Congress Cataloging-in-Publication Data:
Guarnaccia, Steven.
 Hi-fi's & hi-balls/Steven Guarnaccia and Bob Sloan; major
photography by Pete McArthur.
 p. cm.
 ISBN 0-8118-1663-X
 1. Bachelors—United States—History—20th century. 2. Bachelors—United
States—History—20th century—Pictorial works. 3. Life style—United States—
History—20th century. 4. Life style—United States—History—20th century—
Pictorial works. 5. Nineteen fifties. 6. Nineteen fifties—Pictorial works.
I. McArthur, Pete. II. Title.
 HQ800.3.G83 1997
 305.38'9652—dc21 96-45576
 CIP

Printed in Hong Kong

Book and cover design: Susan Hochbaum
Cover and chapter title photography: Pete McArthur
Additional photography: James Worrell and David Spear

Distributed in Canada by Raincoast Books
8680 Cambie Street
Vancouver, British Columbia V6P 6M9

10 9 8 7 6 5 4 3 2 1

Chronicle Books
85 Second Street
San Francisco, California 94105

Web Site: www.chronbooks.com

hi·fi's ★ hi·balls

THE PAD

A bachelor's castle was his pad.
More than just home, it was
the center of his sybaritic life,
the locus of his pursuit of pleasure,
the place where he housed
his sacred artifacts — his bongos,
hi-fi, and cocktail glasses.

THREADS

Sharp threads distinguished
the bachelor from the working stiffs
of the world. His vines were
exotic, streamlined, and casual.
But above all, stylish, to catch
the eye of a passing honey.

LIFE'S A GAS

Leisure was to the bachelor
what blood was to a vampire. His
hunger for relaxing was insatiable
— golf, bowling, cigars, cocktails
and, of course, ogling a pair of
swell gams — a bachelor's
work was never done.

GROOVES

Album covers were definitely weird,
visions of surrealistic kitsch.
And the music was equally strange,
the exotic rhythms and
far-out sounds of what we now call
Space Age Bachelor Pad music.

51

LAFFS

Bachelor humor wasn't just
about jokes — it was abstract, subtle,
and introspective. Hip stand-up
comics emerged as the conscience
of the age. Hey man, like dig, did
this ever happen to you?

63

HIPSTER

Hip to the latest sounds,
donning beret, shades, and sandals,
the hipster slouched his way to the
nearest coffee shop to hang loose
with an espresso. There, this
mellow fellow would play it cool
and flip the lip with a
with-it chick.

73

THE WOLF

There was a little bit of the
wolf in every bachelor. His whistle
could be heard across the
nation, reveille to a hot number
passing by, letting her know a wolf
was around and dug her
snazzy chassis.

83

The 1950s and 1960s **gave rise to a curious phenomenon in America — the** swinging bachelor. **Riding the crest of prosperity after WW II, young men of this generation weren't ready to settle down. Domesticity was not their groove. They dreamed of pushing a** sportscar **above 60, not a mower across the lawn; of changing records on the** hi-fi, **not diapers in the den. And their idea of an addition to the house was a new bamboo stool for the** jungle bar. **They relished their independence, and around them formed a unique culture of cool and often outlandish hipness, a distinctive life devoted to music, humor, clothes, and** the fairer sex.

And thus the bachelor was born — a walking libido in a Leisurewear suit, a rebel in a goatee **and silk-toed shoes, on the prowl for** hip chicks, **fast cars, cool sounds, and "swellegant threads," pausing only long enough to find a shady spot to "take 5" and "cop a few Z's." Once rested, he'd slap on some suave cologne, rub a bit of** Brylcreem **through his hair, and get back to his sybaritic life.**

And what a life it was! Liberated from marital obligations, these men were out to have a ball. Anything that was square, that was "strictly from Dullsville," was left behind. Nesting was out, mashing was in. Scotch and water gave way to frozen mai tais. And any female who was unescorted was brazenly approached by a wolfish bachelor — "hey sugar, are you rationed?"

Part beatnik, part Rat Pack wannabe, bachelors rejected the button-down, working stiff way of life. They were looking to expand their horizons. After all, this was the '50s — the Atomic Age. Television brought the world into living rooms. Beatniks roamed Greenwich Village and San Francisco. Magazines ran articles about guys fleeing Wall Street, rolling up their pants, and walking the beach looking for driftwood to turn into table lamps. It was time to break out, not fit in. The swinging bachelor didn't look to throw away his prime years worrying about mortgage payments and training wheels. He needed to swing, to grab a cocktail and a stewardess and enjoy himself. Like the songs says, "Let me show you where it's at / The name of the place is 'I like it like that.'"

And bachelors definitely knew what they liked. Everything in their world was redefined

to suit their style — clothes, furnishings, cars, music, even the way they talked. A simple "good-bye" wouldn't suffice when you could say "In a while, crocodile."

Though he needed a job to pay the rent and keep him in crepe-soled shoes, the bachelor resisted becoming the typical organization man. But like his working friends, he wouldn't scoff at a lazy afternoon playing a round of golf. Out on the links, replete in his bamboo shades and sports shirt adorned with leaping marlins "dimensionally embroidered" on the pocket, he'd show off his style to the corporate-types. "Fore, Daddy-o!"

Evenings he spent in his lair — the bachelor's pad. There, in his cooly appointed digs, he was surrounded by the essence of his bachelor-ness. Fellow pleasure seekers dropped by for cocktails and canapés, and to cavort in his hip surroundings. Later, with his main squeeze, he could turn the lights down low, put on a Jackie Gleason mood album, and, in the eerie glow of his lava lamp, utter his well-practiced come-on lines and proceed to make his move.

He was insolent and irrepressible, our bachelor. He cruised with the top down, left his shirt-collar open, wore sunglasses at twilight, and spoke in a lingo not everyone

understood. He even laughed at different things, embracing a hipper, more abstract sense of humor. The comedians he dug weren't joke tellers. They were talkers, candidly regaling the listener with a steady flow of ideas, anxieties, and complaints — from the promised doom of the atom bomb to the tribulations of a first date. The, '50s comic was often a slouch-shouldered nebbish wearing tortoiseshell glasses, like Wally Cox — Mr. Peepers — so paranoid that when the football team went into a huddle, he was sure they were talking about him. Or Stan Freberg and Roger Price, who looked like accountants but had an absurdist view of the world worthy of Ionesco.

Urbane and glib, a bachelor was part international spy, part Atomic Age hipster, part fashion plate. He built his hi-fi from scratch with speakers as big as Sherman tanks, and pushed them to their ultraphonic limits with his audio test records, though he desired a high level of fidelity only with his music. His heroes sported Hawaiian shirts and drove Corvette convertibles. He was a new member of the tribe, more trendsetter than bread winner, all wrapped up into one smooth-talking, cocktail-mixing package — the swinging bachelor.

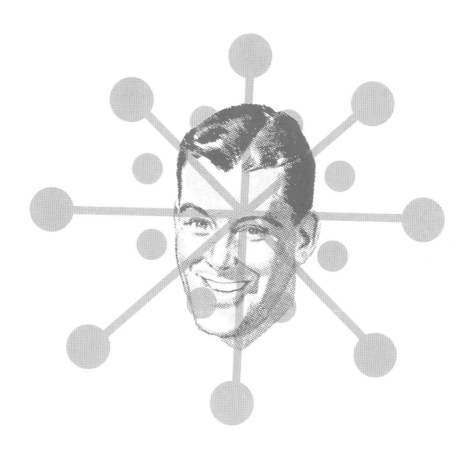

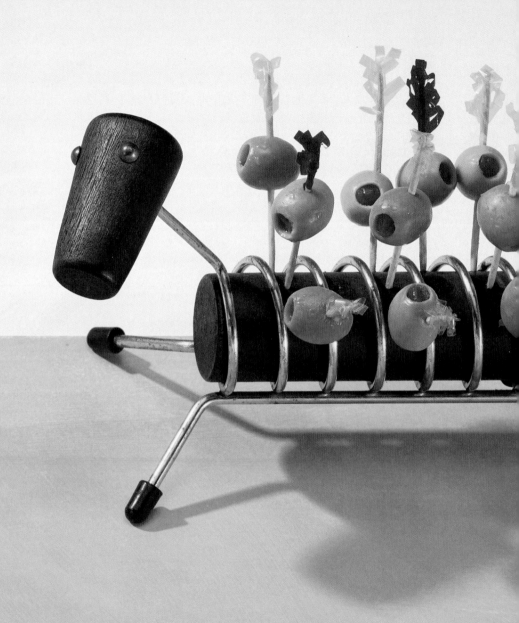

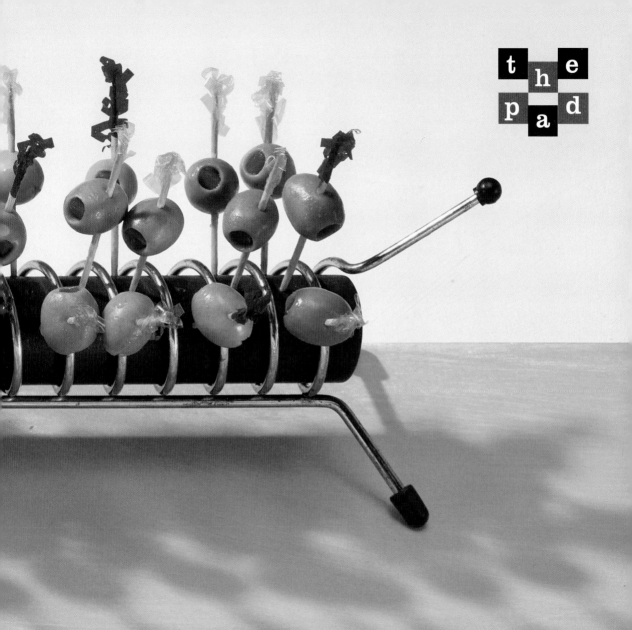

THE CENTER OF THE BACHELOR'S KINGDOM WAS HIS PAD. MORE THAN JUST HOME, IT WAS A cathedral devoted to the swinging life, the shrine of the sybarite, a paean to everything cool and hip. A bachelor's digs were meant to be dug. ❊ A guy in the know with a little dough could display his good taste in his pad. With the help of magazine ads, he chose his furnishings and appointments himself. Through the mail he could order chairs, tables, record holders, a Hide-a-bar. There would be no help from mom—anything she'd approve of would definitely have to go. ❊ A bachelor's pad was not like the house he grew up in. Instead of a grand piano, a pair of bongos graced the living room. Plush armchairs were replaced by sleek seats of chrome and leather. And quaint samplers gave way to drink trays with wacky sayings that lined the wall of his well-stocked bar. Scattered about were souvenirs and accessories from around the world, there to make any stewardess, who'd seen a few things herself, feel right at home. ❊ A small kitchen housed the bare essentials: a fridge (primarily for ice and olives), a cheese board, a can opener, at least one ice crusher, and the bachelor's principal appliance, a blender. ❊ But most of the pad was devoted to living room and bedroom, the two poles of a bachelor's universe. The living room featured the couch—there to drape a girl on (the girl there to drape an arm on). The bedroom featured the bed; strategically placed mirrors were optional. Like a river coursing to the sea, a well-designed pad had a natural flow from the couch to the bed; The licentious mood in a bachelor apartment was fecund to none. ❊ The altarpiece in this cathedral of leisure was the hi-fi. From it issued forth musical sermons testifying to the supremacy of bachelorhood and the greater glories of the swingin' life. The wire record stand stood loyally beside it like a beadle, ready to supply the required platter. ❊ The pad was where a bachelor entertained, where he invited a girl to see his etchings, where he hung out with his fellow wolves and hipsters. In the safe confines of their hedonistic clubhouse, they made dates, sipped cocktails, smoked cigars, and patted themselves on the back for being the salacious yet charming reprobates they were.

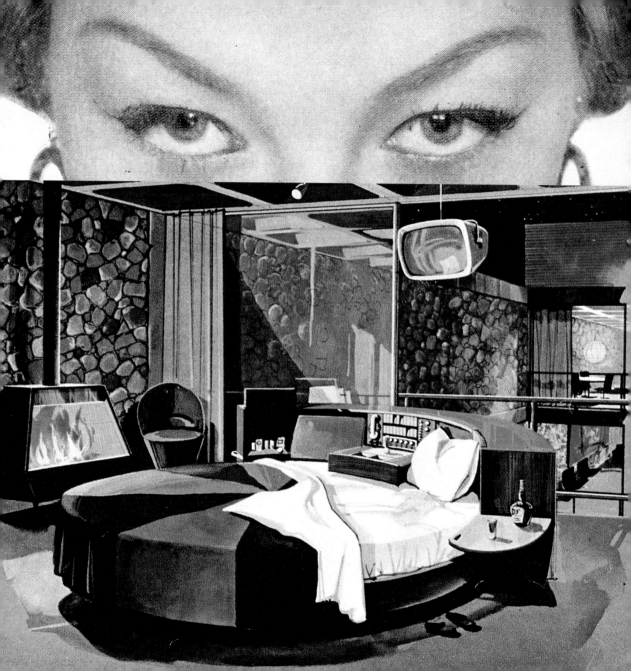

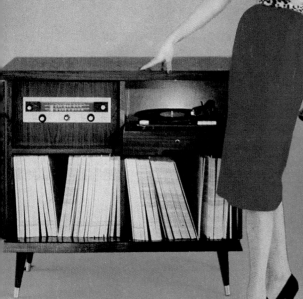

HiFi

& MUSIC REVIEW

March,

TOSCANINI
Viewed in New Perspective

16 RPM RECORDS
Hour of Music per Side

SPEAKER BAFFLES
The Why and How

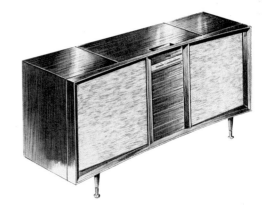

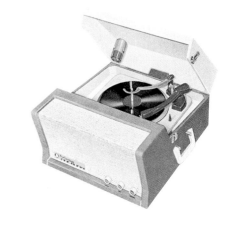

Anyone can listen to music, but to listen to sound, now that takes some doing. For Hi-Fi nuts, sound was the appeal. And not just any sound. Record companies were fiercely competitive when it came to boasting about their latest technological breakthroughs. Album jackets devoted more space to the recording technology than to who was making the music — SurroundSound, 360° Sound, Full Spectrum Pan Orthophonic Sound, Stereophonic Curtain of Sound, and the oxymoronic but tantalizingly provocative Visual Sound! There was sound that did everything except wash

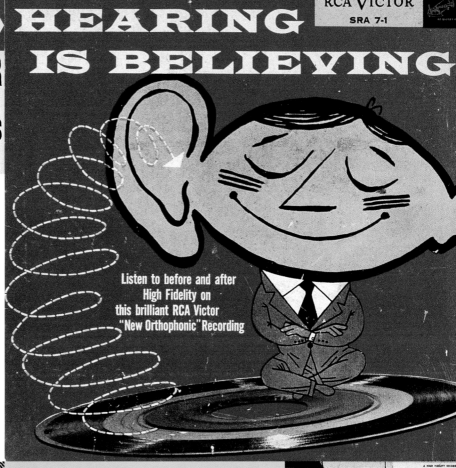

AUDIO FIDELITY DFS 7777

STEREO ▶

SPECTACULAR
DEMONSTRATION
: SOUND EFFECTS

MUSIC BIG AS LIFE

HEARING IS BELIEVING

RCA VICTOR

SRA 7-1

Listen to before and after
High Fidelity on
this brilliant RCA Victor
"New Orthophonic" Recording

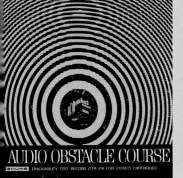

AUDIO OBSTACLE COURSE

SHURE TRACKABILITY TEST RECORD (TTR 101) FOR STEREO CARTRIDGES

your dishes. For audiophiles it was a dream — fidelity
higher than anything in real life — sound that could
careen around their pads with reckless stereo abandon
like a swarm of rhythm-mad bees, that could test the
outer limits of their hi-fi system, riding up and down the
frequencies and pushing the envelope of the RIAA Curve
beyond their wildest fantasies. It was transcendent sound.
Thoreau wouldn't have holed himself up pond-side in a
cabin on Walden had he been able to dig the fidelity of
some Persuasive Percussion on his hi-fi.

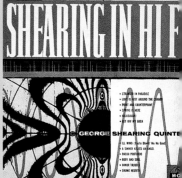

A HIGH FIDELITY RECORDING

SHEARING IN HI F

GEORGE SHEARING QUINTE

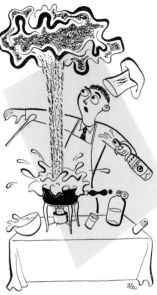

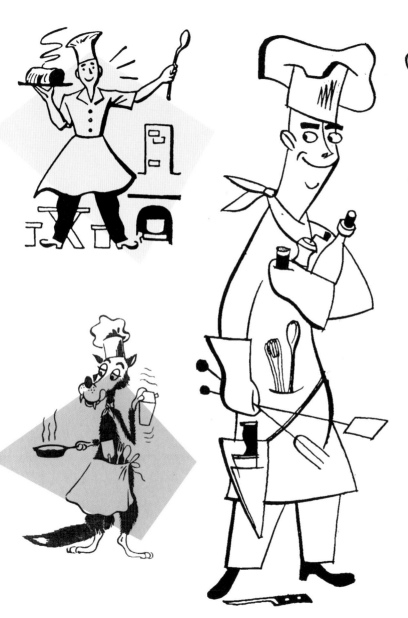

As inexplicable as the cicada suddenly appearing in the trees, a bachelor would get the urge to go into his kitchen and cook. The results were usually catastrophic. Trying to impress a date, he'd vainly follow the recipe but inevitably wind up producing some mutant culinary creation reminiscent of what Steve McQueen fought off in *The Blob*. Fine cuisine was not the bachelor's forte.

First, hide all incriminating evidence — girlie mags, dirty socks, nudie playing cards — then open up the bar and get a stack of platters on the turntable, because it's cocktail party time!

Getting the pad ready might take all afternoon. There was probably a week's worth of crusty dishes in the sink; the lampshade you wore on your head at the last party needed replacing. And the beaded curtains needed straightening.

But the most crucial preparations involved the bar — glasses needed cleaning — tall ones with painted palm trees for the Zombies, martini glasses for the martinis, carved Tiki-style tumblers for jungle-hued potions intended to get the vixens In The Mood — ice needed crushing, and the blender needed plugging in.

The definitive cocktail party consisted of several bachelor friends and an equal number of well chosen and unattached women, discreetly referred to as "fair game." The evening started off around the coffee table, guests sipping cocktails built

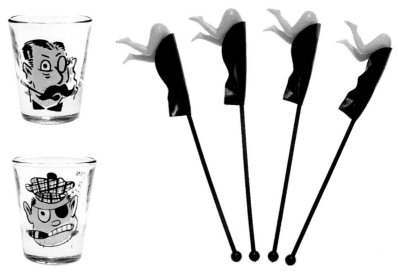

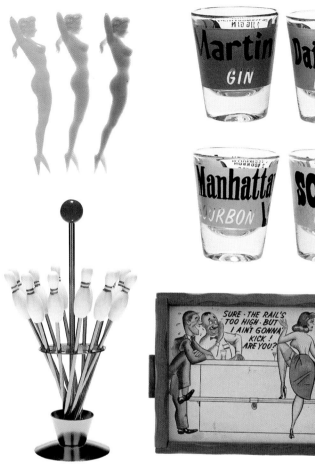

by the host and taking proper notice of any swanky new additions to the pad's decor, like the wire sculpture of the saxophone and dancing eighth notes now hanging on the wall. There was also food, prepared following recipes given in the latest *Esquire* — cubes of imported cheeses, smoked oysters, Ritz cracker canapés, and, if avocados were available, a batch of that exotic new dip called guacamole. But the food was there simply to keep the guests from falling over — until the host wanted them to.

Then it was time to read a few cocktail napkins — women have the curves and men have the angles — inducing titters (from the girls) and hearty guffaws (from the bachelors). A quick segue to marvel at the amazing fidelity of the hi-fi, then a round of Ratfink — to loosen everyone up — which led up to the magic moment when you pushed the recliner aside so there was room enough for everyone to cha-cha until late into the night.

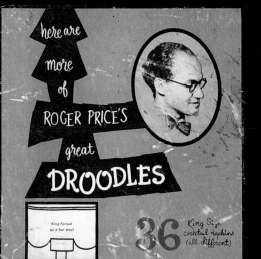

Very Finny

36 Cocktail Napkins

Ed Bart Fielding

"I'll see you and raise you a fin"

Fractured French

Pièce de résistance (Shy girl)

36 cocktail napkins

36 different illustrations

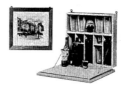

picture bar

Hung in your office, bar or den, this masterpiece looks just that. But lower the frame, and voilà! 3 gold-capped bottles, 6 highball glasses, 2 shot glasses and a mixing jar. Wormy chestnut-finish frame fits any decor. Prints are by master painters. Glassware included. $20.

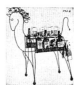

The Portable Pony Bar is a really unique liquor server. This wrought iron horse holds 8 fifths of your favorite booze, has a serving surface for glasses, a towel rack, and holds napkins in its metal mane. For indoor and patio serving, the Pony Bar wheels anywhere you lead him. $$50.00.

AUTOMATIC SWIZZLE STICK

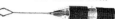

Absolutely the last thing in mechanized drinking. This battery-operated stirrer saves precious time between drinks, can be operated by even the most unsteady hand, and is a clever and amusing addition to your bar set. Chrome and leather handle contains flashlight battery and small electric motor. Only $5.00. Satisfaction guaranteed. Send check or money order to:

Bar Boutique

Box #3376 Merchandise Mart, Chicago 54, Ill.

Mention "men's club," and you usually think of worn leather armchairs, dark wooden book shelves, dreary rugs, and dusty drapes. Decor that was staid and established, that invited falling asleep in a chair next to a snifter of cognac. But bachelor digs were anything but old fashioned. They were designed to be up-to-date, full of metal and chrome, a clubhouse for the adventurous, a pad to launch the latest designs. Furnishings in a bachelor's digs were meant to wow, to prompt the new receptionist at the office, invited over for a drink, to say "How do you even sit on that?" Chairs looked like barbecues. Couches resembled operating tables. A chaise could be in the shape of a tuna. This was the furniture they'd have one day on spaceships to Mars. It may not have been all that comfortable to sit on, but for a bachelor, it was comforting to know there was nothing square or unhip about how he lived.

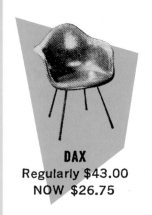

DAX
Regularly $43.00
NOW $26.75

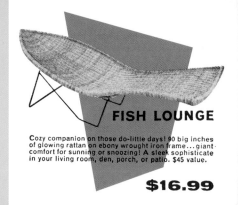

FISH LOUNGE

Cozy companion on those do-little days! 90 big inches of glowing rattan on ebony wrought iron frame...giant comfort for sunning or snoozing! A sleek sophisticate in your living room, den, porch, or patio. $45 value.

$16.99

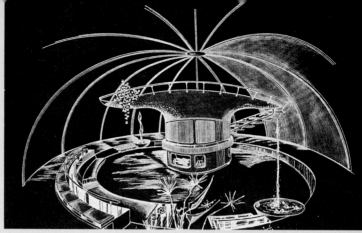

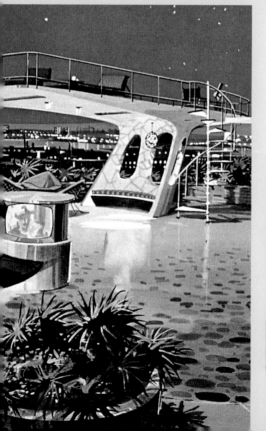

The apex of bachelor living was the glass-walled penthouse, the kind of pad Hugh Hefner would have. Leaning on the railing next to your date, drinks in hand, gazing out over the flickering lights of a city full of squares, you could rest assured your pad did your seducing for you.

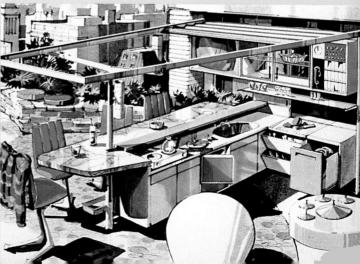

IT WASN'T ONLY WHAT THE GRAY FLANNEL SUIT REPRESENTED THAT THE BACHELOR REJECTED, it was the suit itself. Clothes became a vital expression of who he was and how he wanted to live his life. ❊ Bachelors dressed differently than their fathers. Suits, rather than being wide and boxy, were trim and angular. Like cars, they were becoming streamlined, lapels narrowing, built for speed. These clothes were not for someone planning to sit behind a desk his whole life growing corpulent. Bachelors were on the move. Clothing ads championed freedom, even for underwear — "Briefer than boxers, freer than briefs, they're Allen-A Walkers — They don't ride!" If you were Napoleon Solo, the Man from U.N.C.L.E., you needed a suit that let you dodge bullets, return fire, and still look swank when you arrived, on time and only slightly out of breath, to meet your date for lunch. ❊ Ties, too, grew thinner and more sedate. Gone were the florid excesses of the '40s, the swirling Technicolor patterns on wide swatches of silk as if you were wearing a still from *Fantasia* . A bachelor's tie was, in homage to the Jet Age, sleek and taut, with only the subtlest geometric pattern. ❊ But his tie was probably the only thing straight and narrow about the bachelor. His cavalier behavior invited adventurous attire. An evening of girl-watching might require pegged pants and two-toned winkle-pickers — shoes that were sure to grab a hip chick's eye. Cruising in his convertible sports car demanded a tweed cap, sports jacket with suede elbow patches, and an ascot. And for a round of golf, nothing short of a Banlon shirt with embroidered front pocket and Haggar slacks with slash pockets would do. ❊ With the bachelor came the emergence of fashion for the common man. Until then it was primarily dandies or top-hatted Beau Brummells who strutted down the avenue in their elegant attire. But now the Average Joe could leaf through *Esquire* and find clothes designed just for him. Snappy clothes, fashionable without being fey. Clothes that gave him a distinctive look yet still identified him as a stalwart bachelor on the prowl.

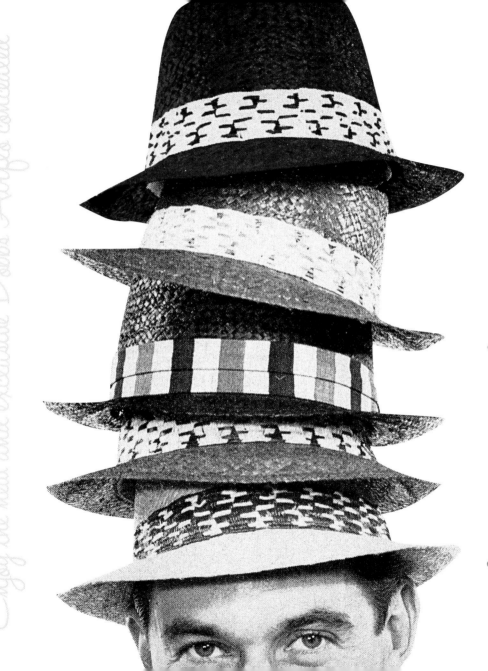

"open weave under the band for smart, cool comfort."

"Enjoy the new and exclusive Dobbs Airflo concealed

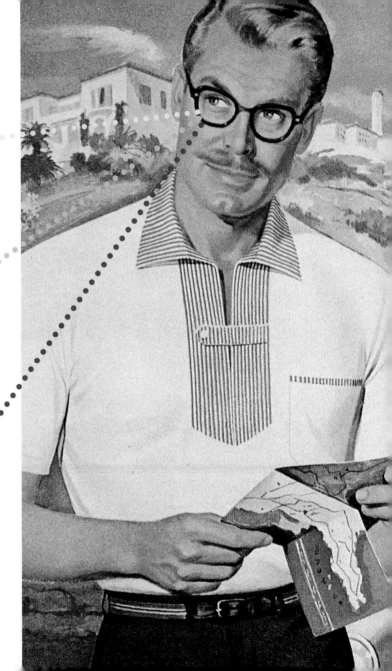

"I WON'T WEAR A THING BUT TOWNE AND KING!"

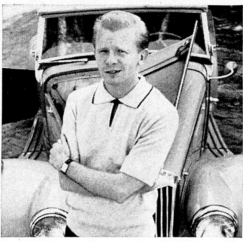

says **CYRIL OLDFIELD,** hot rod builder.

Mark Twain said, "Beware of any venture that requires new clothes." The bachelor says "Beware of any venture that doesn't." Clothes may not make the man, but "killer threads" definitely made the bachelor. Collars, seams, necklines, pockets all became the loci for a splash of color, a bit of embroidery or design that announced, as clearly as a neon marquee, that there was a bachelor here. The most distinctive bachelor attire fell under the heading of Leisurewear. It says something that they needed a name for it, that time spent living the bachelor life was so important that it required its own style of clothes.

MILBANK, SO. DAK., May 26 — Cyril is readying his jalopy for a drive to Lubbock, where he will take his final exams in wire tapping at Texas Tech. His heap (if you will pardon the expression) is a Crosley station wagon powered by a 1956 Cadillac motor. Power braking is achieved by a drag device weighing more than Cyril. "You gotta dress for it," Cyril says. "Except for pants and shoes, everything you can see is TOWNELLA."

TOWNELLA Sweater Shirts; premium quality imported fibres. 6 California colors; S-M-L-XL — 10:95. Crew length sox in matching colors; 10½ -13 — 1.75.

TOWNE AND KING, LTD.

Coordinated Knitwear
595 Broadway, Redwood City, California

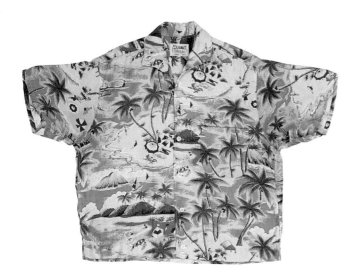

Brazen as a baboon's ass, nothing exuded bachelorness more than the Hawaiian shirt. You wouldn't go to work wearing one and that was exactly the point. Its exotic colors, wild designs, and iridescent fabric announced in no uncertain terms that adventure and a cool cocktail were just around the corner.

--

Put the spats and the shoe together and you come up with the two-toned numbers so favored by the sporty bachelor. They were a far cry from the sullen brown wing tips working stiffs trudged to the office in. But two-tones exuded lightness, a bounce in your step, the kind of shoes to learn the mambo in. Shoes are easy to overlook, being in the purlieus of fashion. But any bachelor worthy of his mai tai knew that ignoring the shoes meant your fashion statement wasn't complete, that you were just parvenu, a bachelor manqué.

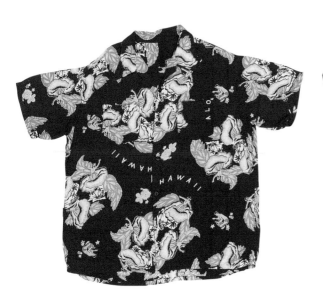

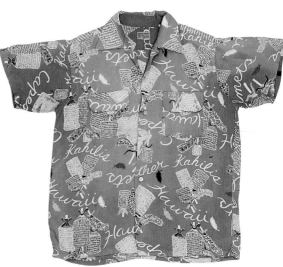

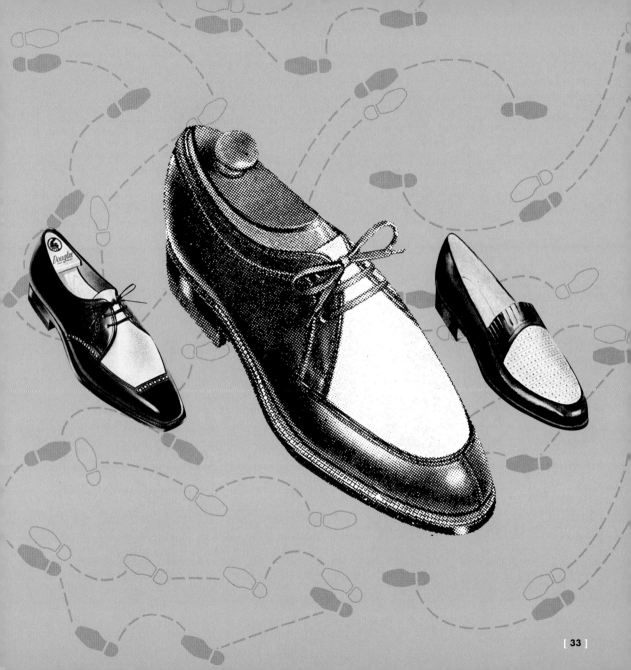

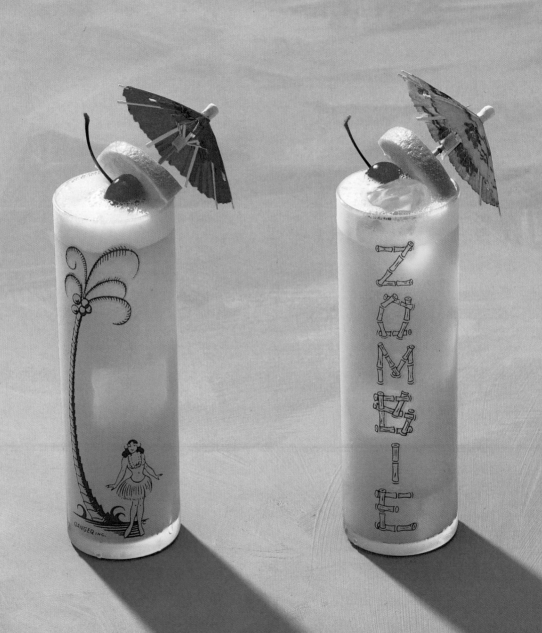

LIFE'S·A·GAS

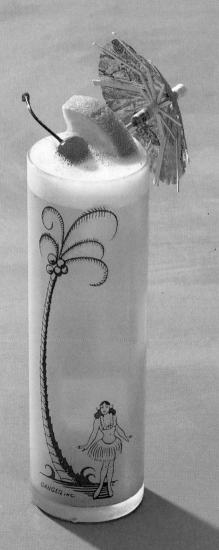

LEISURE TIME WAS THE BACHELOR'S LIFEBLOOD. A TRUE BACHELOR TREASURED HIS LEISURE time and savored it whenever possible. Without it, he might as well toss in his cards and walk the plank, tie the knot, strap on the ol' ball and chain, you know, fall in love and get married. ✳ Like, dig, with no strings attached, a bachelor was free to find the latest kick and give it a whirl. There were no hedges to trim, no PTA meetings, no weekends entertaining in-laws. His time was his own. But living a life of leisure was a lot of work, having to decide between such labor-intensive undertakings as golf, bowling, driving with the top down, fishing, heading down to the beach to dig for clams, or kicking back in the recliner with a Havana cigar and a cool cocktail. So much relaxing to do, so little time. ✳ The first step to enjoying free time was to head to the magazine rack at the local drugstore to pick up the latest copies of *Esquire* and *Playboy*, the two ora-cles of the devout sect of the bachelor. There were also a host of other rags trumpeting just how pleasurable life (as a bachelor) could be. Car magazines kept him up to speed with the latest in convertibles and which nifty little roadster would most likely catch a girl's eye. A sports rag would keep him on par with any new developments in the world of athletics, most important, what he should be wearing on the links or the tennis court. ✳ Another essential leisure-time undertaking for the bachelor was stocking up. The bachelor life required an array of supplies. The closet, the pad, the record collection, and the bar all needed regular replen-ishing. After all, a rival bachelor with the latest sounds and a sweller set of drapes might just have the edge that sends a chick with a snazzy chassis moving in his direction. ✳ But sometimes the torrid pace of so much leisure would overwhelm the sensitive bachelor that all he wanted to do was sit in front of the tube or pick up a magazine and think about a trip to somewhere tropical, where he could lounge on a chaise in the shade of a palm tree while a buxom young woman with deep bronze skin served him a cool drink and talked dirty to him in some mysterious foreign language.

AUGUST 1960 FIFTY CENTS

ROAD &
TRACK

THE MOTOR ENTHUSIASTS' MAGAZINE

While the yahoos were souping their hot rods, putting on chrome heads, and painting them with primer, the bachelor rode in style in a sports car or sleek, streamlined sedan, preferably with the top down. If driving with a chick, the driver of a convertible let the world see what a dish delish she was. If driving solo, a girl could check out your fine threads and take notice of the empty seat next to you just waiting to be occupied by a chick with free-wheelin' hips and no cover charge.

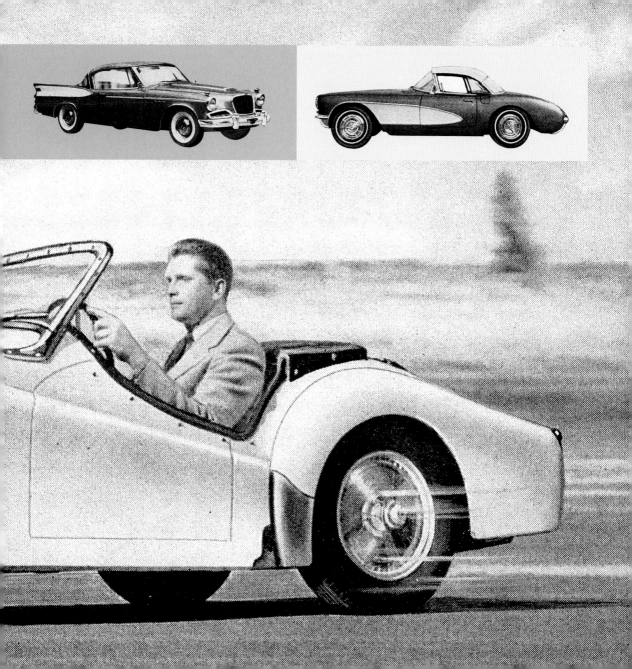

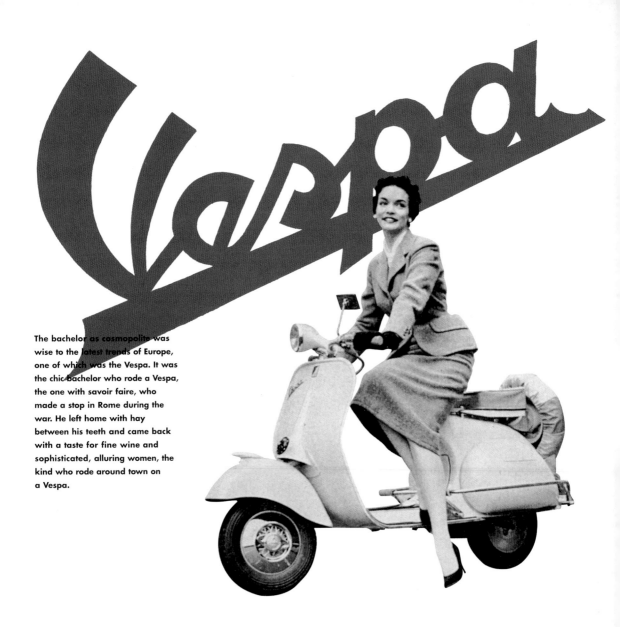

The bachelor as cosmopolite was wise to the latest trends of Europe, one of which was the Vespa. It was the chic bachelor who rode a Vespa, the one with savoir faire, who made a stop in Rome during the war. He left home with hay between his teeth and came back with a taste for fine wine and sophisticated, alluring women, the kind who rode around town on a Vespa.

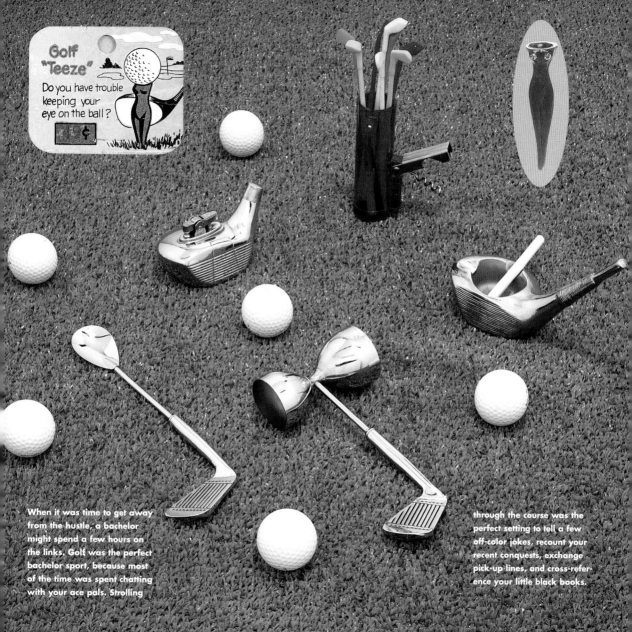

Golf
"Teeze"

Do you have trouble
keeping your
eye on the ball?

¢ ¢

When it was time to get away from the hustle, a bachelor might spend a few hours on the links. Golf was the perfect bachelor sport, because most of the time was spent chatting with your ace pals. Strolling through the course was the perfect setting to tell a few off-color jokes, recount your recent conquests, exchange pick-up lines, and cross-reference your little black books.

[41]

Bachelors had feelings, too. And not just salacious ones. Some bachelors were looking inside themselves and discovering that they had anxieties. That their anxieties had anxieties. And they realized it could be a good thing to find a

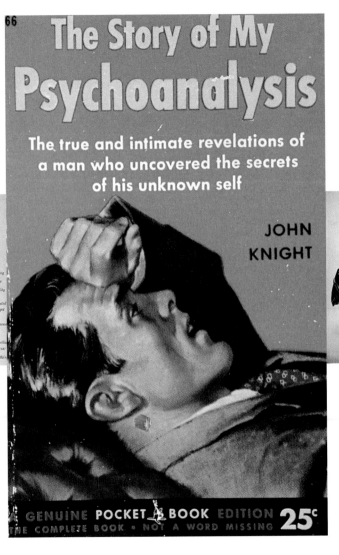

The Story of My Psychoanalysis

The true and intimate revelations of a man who uncovered the secrets of his unknown self

JOHN KNIGHT

GENUINE POCKET BOOK EDITION 25c
THE COMPLETE BOOK • NOT A WORD MISSING

Dashing and debonair, the spy was perhaps the ultimate bachelor. Reckless, yet never ruffled. Daring, yet tender. His Baretta in one hand, his other hand holstered in décolletage, he was an epiphany of suave. Other men dreamed of

ongs of **couch and consultation**

- shrinker man
- the will to fail
- the guilty rag
- stay as sick as you are
- hush little sibling
- real sick sounds
- repressed hostility blues
- i can't get adjusted to the you who get adjusted to me
- schizophrenic moon
- properly loved
- gunslinger, in ballads for adult neurotics
- it must be something psychological

shrink with a comfy couch and talk about their problems, unravel some of the kinks in their conks, give the ol' pumpkin a rest, before they completely wigged out and did something foolish, like get married.

RCA VIC
LPM-15

Inside me...
Jimmie Komack
with Orchestra Conducted by
Dennis Farnon

sharing the spy's adventures and getting their hair to part as neatly. Women longed to be cradled in a spy's arms, having their dresses unzipped, letting him place champagne-splashed strawberries between their teeth.

FEATURING the

SAINT

—on the trail of a world syndicate dealing in dames and drugs!

LESLIE

IAN FLEMING

casino

A JAMES BOND THRILLER

royale

BY THE AUTHOR OF DOCTOR NO

"A superlative thriller. Replete with elegant enigmatic women, superb food and service, explosions, torture, and sudden death."
—Boston Sunday Post

SIGNET 35¢

S1762

Based on the exciting MGM-ARENA TV series

THE MAN FROM U.N.C.L.E.

an all-new adventure by Michael Avallone, as U.N.C.L.E.'s top enforcement officer fights a diabolical THRUSH plan for world domination.

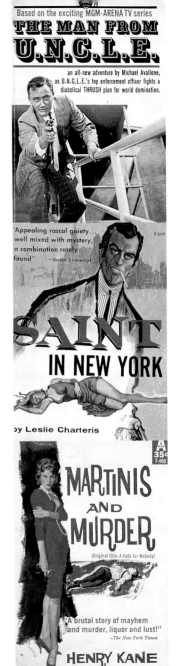

"Appealing rascal gaiety... well mixed with mystery, a combination rarely found"
—Boston Transcript

T-317

SAINT
IN NEW YORK

by Leslie Charteris

JAMES BOND THRILLER

IAN FLEMING

LIVE AND LET DIE

SIGNET

D2052

TOP SECRET

AUTHORIZATION TO TAKE COPIES	C.I.D.37
COPY NUMBER	5
DATE	2/3/67

#112

HAWAIIAN EYE

by FRANK CASTLE

The big M's— money and murder in a tense, seething island caper
Based on the top-rated

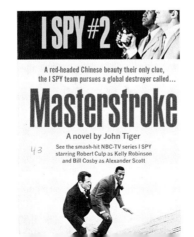

I SPY #2

A red-headed Chinese beauty their only clue, the I SPY team pursues a global destroyer called...

Masterstroke

A novel by John Tiger

See the smash-hit NBC-TV series I SPY starring Robert Culp as Kelly Robinson and Bill Cosby as Alexander Scott

43

35¢
T-460

MARTINIS AND MURDER

(Original title: A Halo for Nobody)

"A brutal story of mayhem and murder, liquor and lust!"
—The New York Times

HENRY KANE

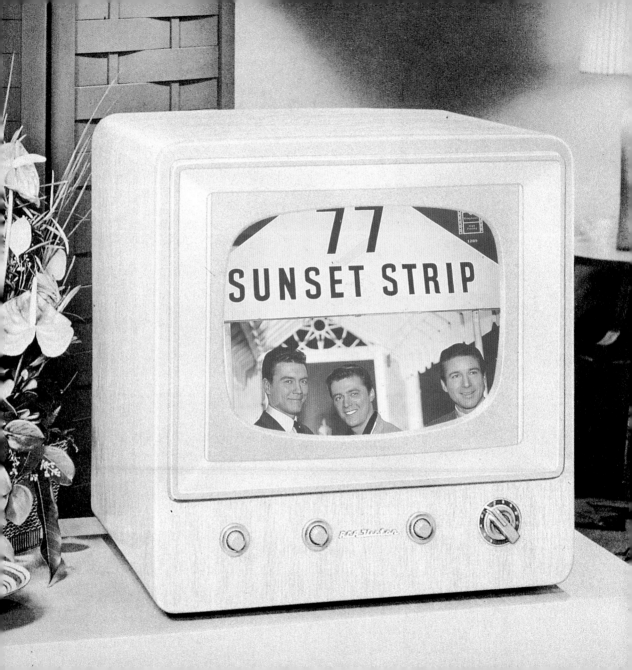

Bachelors abounded on television — *Route 66* and *77 Sunset Strip* both featured swinging guys on the make, carousing and seeking adventures as only a bachelor with a red Stingray convertible could do. Maynard G. Krebs on *The Dobie Gillis Show* set the pace (strictly, like, laconic) for beatniks around the country. And *The Saint*, *The Man from U.N.C.L.E.*, and *I Spy* celebrated the globe-trotting spy.

9:00 **2** SUSIE—Comedy
"Little Bo-bop." Susie tries to persuade Mr. Sands to sign up the best bop musician in the business. Ann Sothern stars.
4 DETECTIVE'S DIARY
"Return to Danger." An Australian amnesia victim comes to London in an effort to prove his identity and recover a fortune supposedly left him by his father. Donald Gray.

<div align="center">Cast</div>

John Wilton	Denis Quilley
Stephanie	Diana Decker
Burnaby	John Longdon
Inspector	Frank Hawkins

Championship Awards

COMPLETE WITH
ELECTRIC BOWLING
PIN CLOCK AND 5
FULL SIZE FIGURES

F99/3C 43" 195.00

FC93/6 21½" 49.50

4.50

B/6 13" 11.25

F92A/6 12" 10.75

F98A/6 10" 9.60

40% DISCOUNT

When it came to double dates, nothing beat bowling. First you had to get into your bowling attire, comfy, yet hip — some Dickies "Slacktime" Ivy Style slacks, a McGregor "Modern Fabulin" sportshirt made with Acrilan, and for shoes, a pair of "Jarman Leisuals," blending comfort and good looks "like they've never been blended before."

LAST PLACE CHAMPS
#636 5" 1.50

Then it was off to the lanes to meet a pair of swingin' chicks. Bowling allowed a persevering bachelor plenty of opportunity to put as many moves on his date as he did on his ball. Usually there was more action on the seats than with the pins. It also encouraged the ladies to bend over fetchingly and wiggle their bottoms, all in the name of good, clean fun.

The bachelor's life was far from aimless. He had his goals — for instance, the long table filled with sumptuous food and drink and luscious women in skimpy tops and floral skirts slit up the side placing ripe fruit in his mouth. To a bachelor, life was a luau — the endless pursuit of a hollowed out coconut filled with an exotic cocktail and a tiny umbrella. And in an attempt to get closer to this dream, he filled his pad with outlandish artifacts that exuded a feeling of the tropics, each a portal to lead him to paradise.

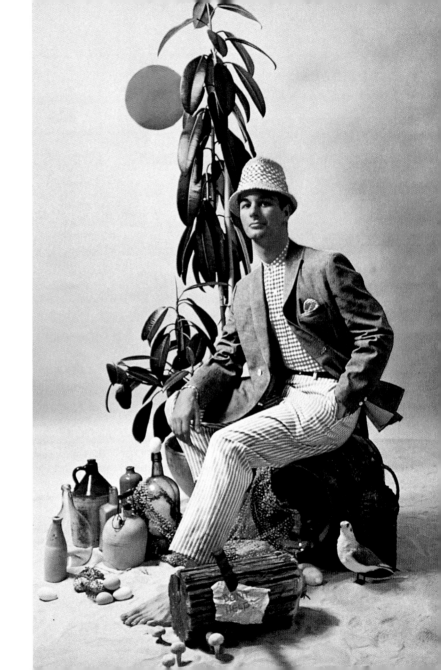

Amazon Jivaro SHRUNKEN HEAD

Amazing replica of fabled native curios with a legend that owners have good luck. A strong stomach helps too because these 4″ heads defy detection from just a few feet away, with remarkably true skin and hair. Sensational to hang in the car, den, bar. Have fun with this guy who got pickled once too often.

$1.50 ppd.

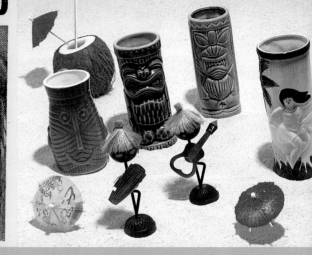

Hawaiian HULA Shimmy SKIRT

Imitate the Rhythm of the Natives of Hawaii!

On the beach, at masquerades, at parties, or even hanging on the wall in your bedroom or den, you will find th: this Hula Skirt provides a lot of amusement. A souven "from the South Seas." Made of paper streamers in varigated colors.

As soon as you receive your Hula Skirt, go up to you room, put it on, and then stand before the mirror and t: to imitate the rhythmic movements of the native Hawaiians. With fascinating grace you can soon learn the wig gles of the Hawaiian "shimmy," etc. Turns any gatherir into a riot of fun.

No. 5706. HULA SKIRT. Adult Size. Price........ **35**
No. 5702. HULA SKIRT. Children's Size.
Price Postpaid................................. **15**

Bushy Cellophane Hula Skirt

Glistening Cellophane Large Sized Hula Skirt. 36-Inch Skirt; 36-Inch Waist
Made of heavy **FLAME-PROOF** cellophane, very

Hawiian Style LEIS

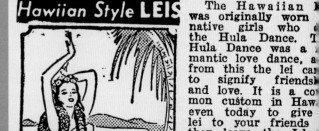

The Hawaiian l was originally worn native girls who the Hula Dance. T Hula Dance was a mantic love dance, a from this the lei ca: to signify friendsh and love. It is a co: mon custom in Haw even today to give lei to your friends they leave the Islar As the ship passes (

[48]

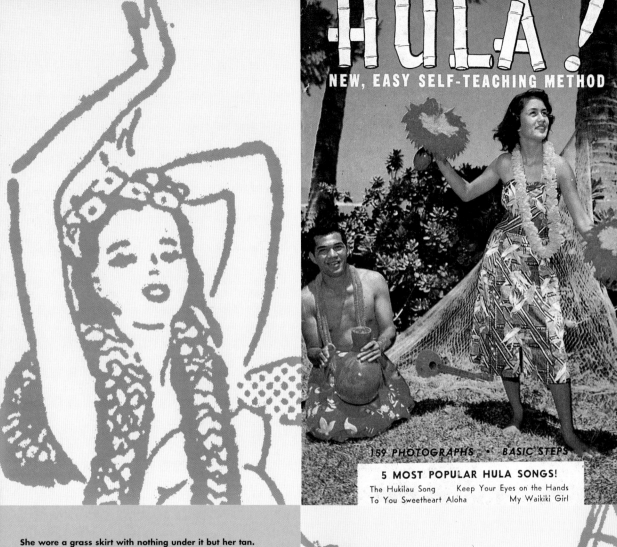

HULA!

NEW, EASY SELF-TEACHING METHOD

159 PHOTOGRAPHS · BASIC STEPS

5 MOST POPULAR HULA SONGS!

The Hukilau Song Keep Your Eyes on the Hands
To You Sweetheart Aloha My Waikiki Girl

She wore a grass skirt with nothing under it but her tan.
Her hips told a story of desire, of steamy lovemaking on
deserted tropical beaches, of a jungle maiden just waiting
for the handsome sophisticate from the city to educate her
in the ways of wanton lust.

grooves

IT WAS MUSIC UNLIKE ANYTHING ANYONE HAD EVER HEARD BEFORE, OR EVER IMAGINED. Weird music. Not jazz or pop or classical or Latin, but some inexplicable combination of them all. The result was a curious musical hybrid, a Surrealist melding of exotic rhythms and far-out sounds, now know as bachelor pad music. ❊ The album covers were definitely out there, bizarre as stills from an Ed Wood movie — men in space suits next to women in low-cut gowns, a cocktail platter adorned with martinis and marimba mallets, an Egyptian princess sprawled at the feet of a bespectacled caveman, all set against a lurid and cheesy Technicolor background. ❊ But even these incredibly fantastic covers did not do justice to the eccentricity of the music. Music that came from outer space, from imagined cosmic frequencies, intergalactic rhythms, Martian melodies, percussion from Pluto. Music from distant Ports of Call, tropical islands, and far-off lands named with a bongo-like beat — Pago Pago, Topkapi, Tiki Tiki, Bora Bora. Or it came from Rio and Cuba and Mexico, pop songs mambo-ized, filling iniquitous dens across America with a pulsating beat, while the Average Joe tried vainly to cha-cha on the numbered footprints spread out on the linoleum. ❊ Some albums were meant to create a soft, luxurious mood, a theme-song for a sybarite, sultry accompaniment to sipping a martini, the soundtrack to an evening of Ritz cracker canapés and seduction. ❊ Others were more atomic, persuasively percussive, packed with pow, awash with wow, 1,500 pounds of percussion, all Go, Baby, Go. ❊ And others proposed to be the music of the Space Age — from the launch pad to the bachelor pad, this is what the monkeys were tapping their paws to when they dropped out of orbit and landed back at Cape Canaveral. ❊ Music groups assembled fabulous assortments of instruments that seemed to come straight from the pages of Dr. Seuss — marimbas and xylophones, timpani, and bongos; slide guitar and bird whistles; gongs and vibes; and a Therimin or two for good measure. ❊ The bachelor was proud of these sounds. Sure, he dug cool jazz and spun a few comedy albums for a laugh, but here was music that was his alone, that was as unique as his approach to life, and there's been nothing quite like it since.

RCA VICTOR
LPM-1046
A "New Orthophonic" High Fidelity Recording

Music for Bachelors

Henri René and His Orchestra

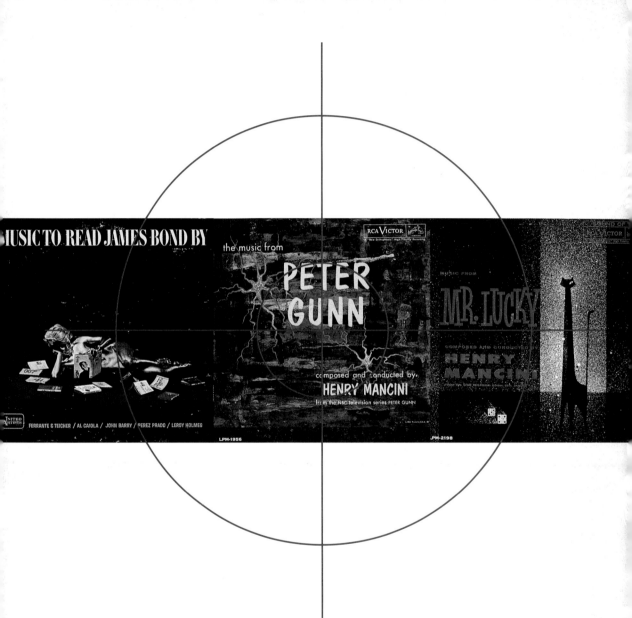

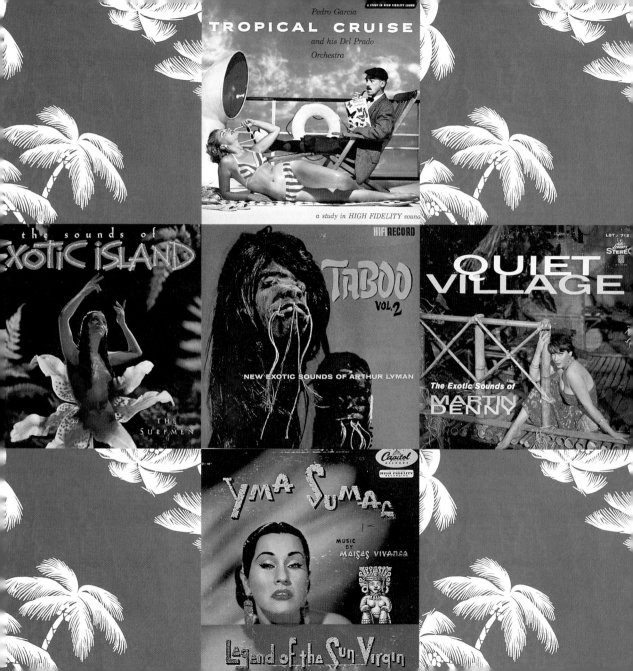

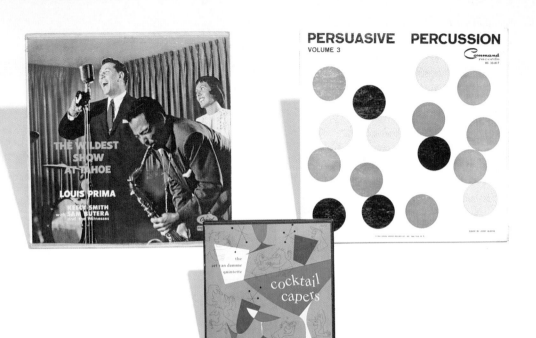

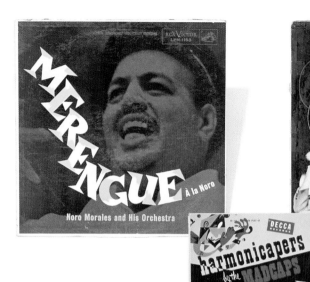

MERENGUE À la Noro

Noro Morales and His Orchestra

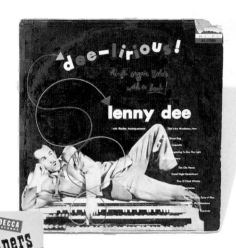

dee-lirious!
lenny dee

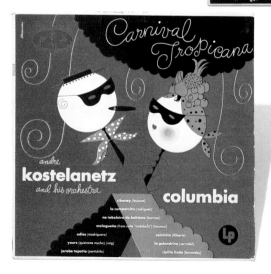

Carnival Tropicana

andre kostelanetz and his orchestra

columbia

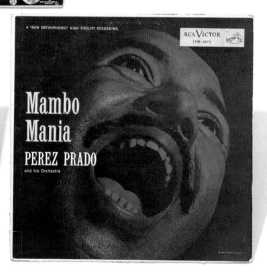

Mambo Mania
PEREZ PRADO and his Orchestra

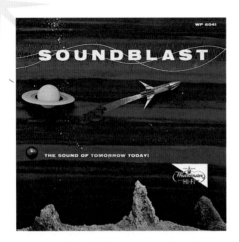

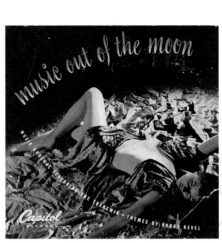

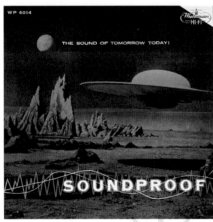

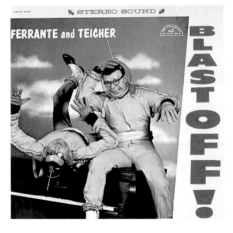

She slays me! What a dish! Oh baby! Va-va-va voom!

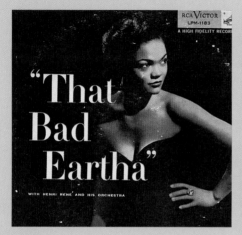

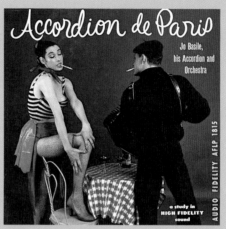

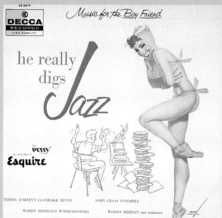

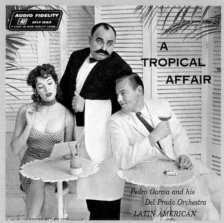

Man oh man! Hotcha! Like, wow! Hubba hubba! Yowsah!

Good gracious! Lord have mercy! I'm gone! Fantabulous!

Cougat! Man, she's on the buttered side! Slaughter me!

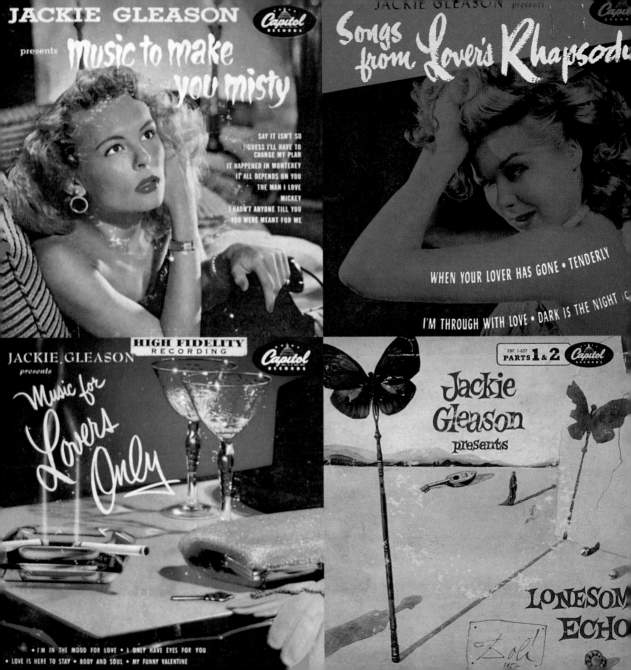

JACKIE GLEASON presents **Music to make you misty**

SAY IT ISN'T SO
I GUESS I'LL HAVE TO CHANGE MY PLAN
IT HAPPENED IN MONTEREY
IT ALL DEPENDS ON YOU
THE MAN I LOVE
MICKEY
I HADN'T ANYONE TILL YOU
YOU WERE MEANT FOR ME

Capitol RECORDS

JACKIE GLEASON presents **Songs from Lover's Rhapsody**

WHEN YOUR LOVER HAS GONE • TENDERLY

I'M THROUGH WITH LOVE • DARK IS THE NIGHT

Capitol RECORD

HIGH FIDELITY RECORDING

JACKIE GLEASON presents **Music for Lovers Only**

Capitol RECORDS

• I'M IN THE MOOD FOR LOVE • I ONLY HAVE EYES FOR YOU
• LOVE IS HERE TO STAY • BODY AND SOUL • MY FUNNY VALENTINE

EBF 1-627 **PARTS 1 & 2**

Capitol RECORDS

Jackie Gleason presents

LONESOM ECHO

The images on the albums were snapshots from a bachelor's soul — the sultry dame holding onto the telephone receiver with longing and desire after his call; the cigarette still burning in his ashtray next to the empty cocktail glasses; the surreal landscape of loneliness with shadows as deep as a Dali after she's gone. No one understood the evolution of seduction better than Jackie Gleason. He was the Darwin of desire. The Great One produced albums for every phase of the bachelor's affairs of the heart. There was music to entice her, to seduce her, to accompany the rapture, to ease her leaving, to listen to while remembering her, to play to forget her. Most of the records featured the rhapsodic playing of Bobby Hacket, one of the finest trumpeters in jazz.

- - - - - - - - - - - - - - - - - - -

Chalice of the gospels, sanctum of the oracle, the record rack held the sacred tablets, a bachelor's records, keeping them in order and preventing them from warping. They also provided a bit of abstract sculpture in his living room, a touch of the moderne, to liven up the decor.

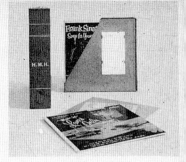
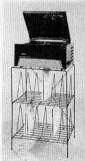
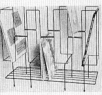

BACHELOR HUMOR WASN'T ABOUT JOKES. JOKES WERE FOR SQUARES, FOR BOGUS BUTTON-down drips, organization men whose idea of a laugh was chuckling on cue in the washroom when the boss delivered an off-color punch line. The comedians a bachelor listened to went beyond jokes, left the Borsht Belt and below-the-belt humor behind and got more personal, sharing their innermost secrets with their audience, as if they were lying on their shrink's couches, shouting on street corners, or talking in your ear from the next bar stool. ✳ Stand-up comics became the conscience of the age, and the nightclub was their pulpit. When Woody Allen did his routine at the Hungry i, it was like he'd peeked in your bedroom and knew all your sexual hang ups and obsessions. Bob Newhart could have been the average guy you sat next to on a bus, talking about his average troubles, but in a way that made them anything but average. Jean Shepherd was just like someone you went to high school with, reminding you about the embarrassments and foibles of adolescence. And Jonathan Winters was the slightly warped uncle you saw once a year at Easter dinner and who somehow through his eccentricities, always said something profoundly funny. ✳ As observers of our ever-fragmenting society, many stand-up comics adopted the telephone as a central motif in their routines. People didn't talk in person anymore, they spoke on the phone, like the mother and son in the Nichols and May routine: "I only pray that some day you have children and they make you as miserable as you've made me. That's my prayer. A mother's prayer." Or Shelly Berman's one-sided phone calls, such as the frantic one he made to a department store alerting them that there was a man hanging from the sixth floor window — "Excuse me, but there's a... yes, I'll hold." Or Lenny Bruce, inside the boardroom of "Religions, Incorporated" with Bishop Sheehan on the line — "Listen, Vincent, if you speak to the Pope, see about getting me a deal on one of those Eye-talian sports cars." ✳ On the print side, cartoonists were delving into the abstract, creating expressionistic gags out of drawings that looked like oddly shaped coat hangers. Artists like Saul Steinberg, Virgil Partch, and William Steig drew angular, geometric characters fractured by urban angst. They bravely fought back against a faceless society, trying to uphold the sanctity of the individual. Punch lines (if there were any) usually had something to do with a tender soul being dispassionately overwhelmed by a mechanized modern world. Humorists, cartoonists, and comics alike were fighting the battle of Us vs. Them, and even though Them seemed to be winning, Us was putting up the nobler, and funnier, fight.

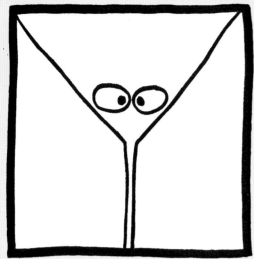

Double martini

Ship arriving too late to save drowning witch

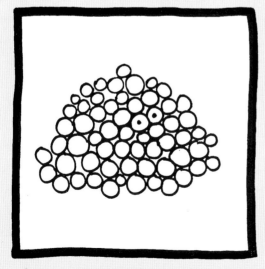

Strip tease dancer hiding in a pile of grapefruit

Four elephants inspecting a grapefruit

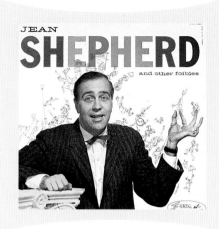

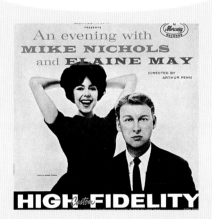

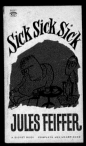

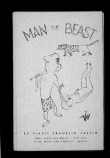

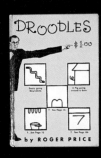

Bachelors weren't prone to much serious reading. But sometimes, if he wanted a break or needed to give his glands a breather, he might pick up a book, especially if it had pictures in it, or slightly risqué cartoons. It would definitely be worth perusing if it provided something pithy to say on the golf course or when romancing a chick. Something snappy, such as a joke book that promoted the idea that it was all right to have sex on your mind most of the time. Or one that reinforced the idea that the bachelor was truly different from the rest of society, not part of the establishment, not one of "them." For the bachelor crowd, Steve Allen retold fairy tales in bop and Shel Silverstein redefined the alphabet. And Jules Feiffer understood the new anxieties arising in relationships between two hiply self-conscious people and then laid them out in incisive cartoons.

- -

Roger Price, creator of the Mad Lib and the Elephant Joke, took the abstract cartoon to its outer limit — the Droodle. The idea was one or more seemingly random geometric shapes suddenly took on meaning when you read the caption underneath. Thus two triangles and a line became the classic "too late to save a drowning witch." The Droodle was advertised as a sure-fire method of "attaining instantaneous popularity at parties" and "determining personality haracteristics...which are none of your business" and "expressing yourself in the modern, progressive manner, requiring a minimum of talent (none)." Thus the Droodle became the opening gambit of choice for a guy on the make. Sitting at the bar next to a member of the opposite sex, he could start Droodle-ing on a napkin and instantly break the ice by making her laugh. That the Droodle was open to more suggestive, libidinous interpretations was an added bonus, one not to be overlooked by the prurient bachelor.

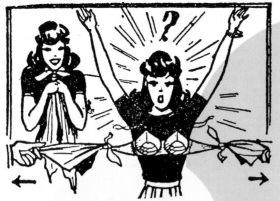

Grant's Funny Brassiere Trick

Most report that this is the laugh hit of any party or show. Can be repeated as often as desired. Get a pretty girl to step forward for a "special trick". Tell her to hold two handkerchiefs in front of her chest. When pulled, handkerchiefs suddenly change to pretty pink brassiere. And is the girl surprised and embarassed! Suggested patter for presentation with each trick that is positively full of laughs. A must! Enough said! Complete. No practise.
No. 3268. FUNNY BRASSIERE TRICK. Price Complete Postpaid $3.75

Moderne Maid Bath Soap

Soap Molded In Shape of Girl Taking Bath

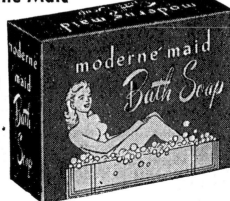

Lather and laughter in these soap surprises. For good clean fun, few things can surpass this novelty. Makes a wonderful gift because it is colorfully packaged to resemble an expensive bath soap, but the fun and surprise is when they open it. Fine quality soap, yes, but it is made in the shape of a girl in bath. Comic gift for all occasions.
No. 2989. BATH SOAP. Price Postpaid . . . 25c

Hula Hula Girl

Two sided. Set of 6 beautiful dancers. Glasses not included.
No. 4662. Price Per Set Postpaid 3.

Whiskey Glass
Very Popular

Size 2" high. Set these up before them. Looks like real whiskey, but wait till they try to drink it. **19c**
No. 2894. Price . . .

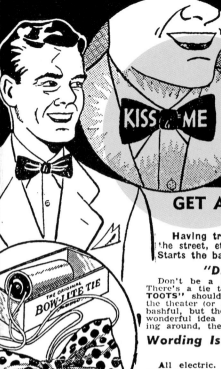

SENSATION!
THE ORIGINAL
BOW-LITE TIE
PAT. NO. 2430607
WITH
CONCEALED BULBS

GET ACQUAINTED IN A HURRY WITH THESE FLASHY TIES

Having trouble getting to meet that slick girl you see at school, on the street, etc? Get one of these ties and let it break the ice for you. Starts the ball rolling in a big way.

"Drop Dead", "Hi, Toots", or "Kiss Me"

Don't be a lost number, get out of the moth balls and start moving. There's a tie to suit every occasion. If you haven't met her yet, the "HI TOOTS" should get you acquainted. If she is the bashful type, get her in the theater (or any dark place) and flash the "KISS ME" signal. You may be bashful, but the light never is, and the girl will be delighted, too, at the wonderful idea and your originality. Or, if some lousy crumb is always hanging around, then you need the "DROP DEAD" tie.

Wording Is Concealed in Tie Until You Flash the Light.
Lights Up Like An Electric Sign

All electric. Switch is concealed in pocket. Tie itself is attractively designed to look very natural, but smart looking when worn, but battery is concealed in pocket. Flash tie whenever you desire. Tie put on in a jiffy; ready tied. Colorful designs. Complete with bulb and battery. **$1.99**

No. 2758. KISS ME LIGHT UP TIE. Price Postpaid...... **$1.99**
No. 2761. HI TOOTS LIGHT UP TIE. Price Postpaid........$1.99
No. 2762. DROP DEAD LIGHT UP TIE. Price Postpaid......$1.99

ar View Mirror

tractive mailing box. ins miniature wooden seat with cover. When of seat is lifted, persees himself in mirror d beneath cover. 5½ x1-in.
2865. Postpaid.. **35c**

1 Born Every Minute

Barnum was right—this proves it. When box is opened there is a cloth blanket over the rear end of the donkey. When lifted, it discloses a mirror reflecting the victim.
No. 2866. Postpaid **19c**

I Cover The Waterfront
In Mailing Box

A real book with pages and attractive cover. Pages are cut and a cloth diaper is inserted.
No. 2848. Postpaid **35c**

Dixie Pe-Cans
In Mailing Box

Beautiful colored box with illustrations of pecan nuts. Place for addressing. When opened two small pots are found.
No. 2843. Postpaid **25c**

Everything a guy needs.

[71]

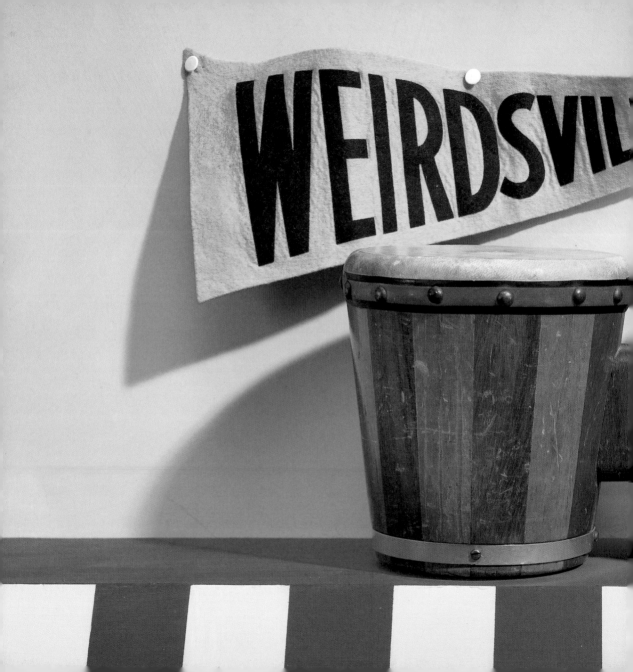

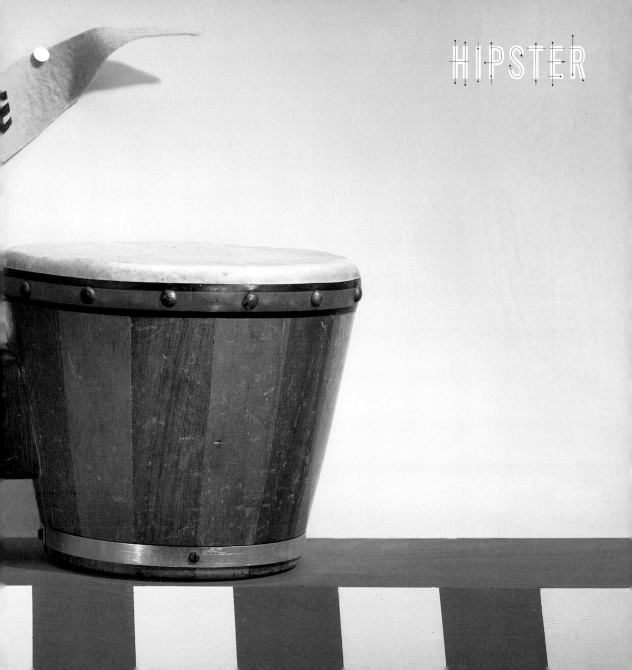

HIPSTER

BACHELORS WITH A BOHEMIAN BENT ADOPTED WAYS OF THE BEATNIKS. FOLLOWING THE lead of jazzmen like Lester Young and Dizzy Gillespie, the beatniks of the '50s created their own hip way of life. Berets, goatees, and shades became standard issue for cool cats and with-it chicks in Greenwich Village and San Francisco, the two capitals of the hip. Poetry, jazz, and long hours sipping espresso were their primary concerns. ❊ Most of a beatnik's day was spent doing nothing but refining his hipness. Work was to be avoided at all costs. A nine-to-five was rigor mortis, Daddy-o. Regular jobs were strictly for the L-7's of the world — squares like Dobie Gillis, who dutifully stocked the shelves of his father's grocery store while his made-in-the-shade friend Maynard G. Krebs lounged about, concerned only that a strap might come loose on his sandals. The beatnik didn't like to get up early and rarely opened his peepers to the early bright. He spent late mornings sitting in the cafe, smoking imported filterless cigarettes through a long cigarette holder. This prepared him for a rigorous afternoon of sitting in the cafe reading poetry to a hep chick who was strictly on the mellow side. ❊ The beatnik's roost was, like his demeanor, always cool and relaxed. The dining room table could have been a used cable spool, the bedroom a mattress on the floor. Doorways were strung with beaded curtains and wire sculptures danced with tribal abandon on the walls. There were bongos everywhere. ❊ The beatnik's cousin was the hipster. Tamer than his devoutly bohemian forerunner, he might actually have a job, though he'd probably wear his sandals to work. Evenings he made the scene in a jazz club, such as the Village Vanguard or the Blackhawk, to dig some hip sounds and righteous riffs. After hours, he'd retire to a cup of espresso with his girl, who, in her bright red lipstick, black turtleneck, and slim black pedal pushers, exuded an elegant coolness.

COOL IT

DIG CRAZY

GED OUT

DADDY-O

HEP CA JIVE

SWINGIN'

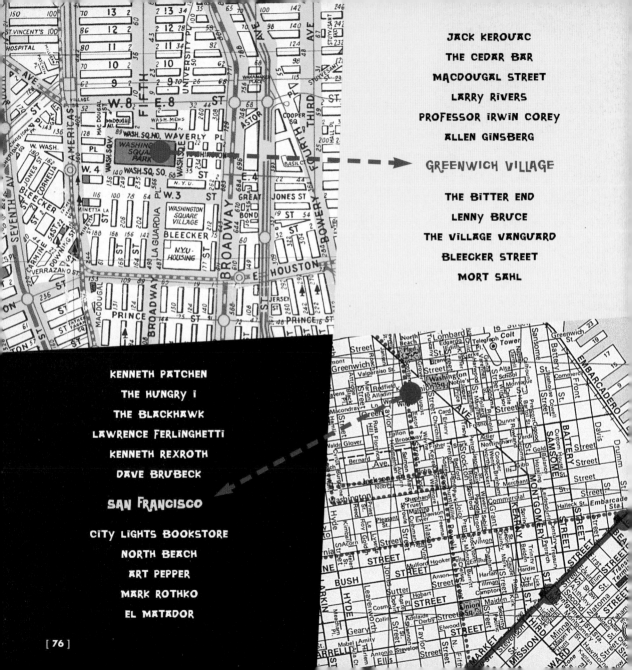

JACK KEROUAC

THE CEDAR BAR

MACDOUGAL STREET

LARRY RIVERS

PROFESSOR IRWIN COREY

ALLEN GINSBERG

GREENWICH VILLAGE

THE BITTER END

LENNY BRUCE

THE VILLAGE VANGUARD

BLEECKER STREET

MORT SAHL

KENNETH PATCHEN

THE HUNGRY i

THE BLACKHAWK

LAWRENCE FERLINGHETTI

KENNETH REXROTH

DAVE BRUBECK

SAN FRANCISCO

CITY LIGHTS BOOKSTORE

NORTH BEACH

ART PEPPER

MARK ROTHKO

EL MATADOR

Like, dig, let the squares grab the ozone. Ixnay on the pencil pushing and give the fast brush to getting middle aisled. A hipster spends his dims and brights diggin' what's strictly solid and would rather wind up in the marbletown than be a jerk of all trades.

Trans. Hey, fellow, don't listen to the establishment. Forget about a job or getting married. Get hip. Be someone who spends his nights and days enjoying what's cool, one who'd rather be in the cemetery than live his life as a square.

what's shakin' what's going on
wigging losing control cat a
hip guy chick a hip girl a gas
having a good time i'm gone
euphoric far-out exceptional
in a groove going well walking the plank
falling in love cooking with gas doing it
right rigor mortis things are slow peeling
a green banana romancing a young girl
catch you on the flip side see you later

STEREO
RS 809 SD

Command records

BONGOS BONGOS BONGOS

BONGOS BONGOS BONGOS

© AWARD PUBLISHING CORPORATION

Think American Revolution, you hear fife and drum. Think hip bachelor, you hear bongos. Ba-ba-dee ba-ba-dop. Anyone who was with it had a pair. Spin Brubeck or Miles on the turntable and jam along with the record. Close your eyes and you were on the bandstand, part of the combo, joining in the collective rhythm of the hipster.

The best bongos, ones with a bona-fide beat that were guaranteed to induce instant cool, were made in Mexico and ordered from the back of a magazine. Sometimes a pair of rockin' maracas were thrown in, for some slick chick to jam along with you.

When cats like James Dean or Marlon Brando were interviewed in their pads, they were laying down some syncopated Latin rhythms on their bongos. A white T-shirt, jeans, shades, and bare feet wrapped around a pair of bongos. For the hipster, that was about all he needed to send him to Groovesville.

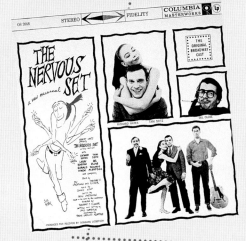

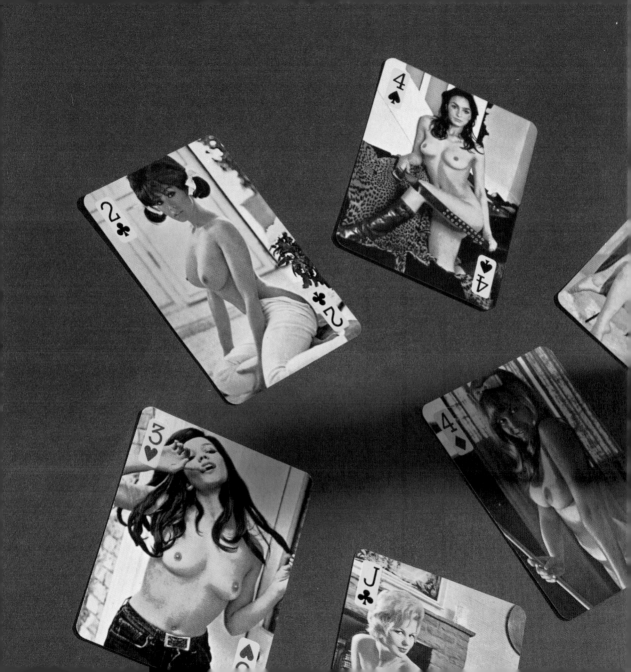

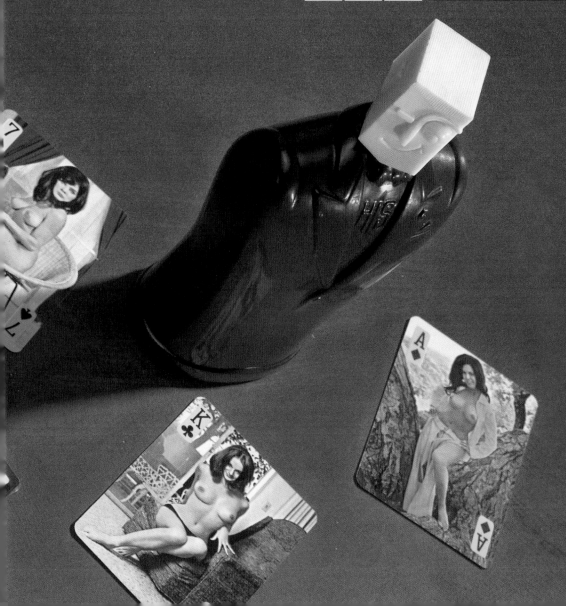

OH MY, WHAT BIG EYES YOU HAVE. IT WAS RARE THAT A CUTE CHICK WITH A SWELL PAIR of gams would pass by a wolf unnoticed. His whistle cut through a crowd. His visceral sounds of lust and longing, like something out of a National Geographic documentary, could be heard at street corners all across America. They were the calls of the Wolf, the bachelor on the prowl. ❊ The first little cutie he worked his whistle on was Little Red, back in the forest. Then, as documented in the classic Tex Avery cartoons of the '50s, after following Little Red through the woods past Grandmother's house, he wound up in the Big City. There Little Red got a gig singing in a nightclub and she wasn't so little any more. The wolf, now dressed as a debonair bachelor on the prowl, gloms her onstage in the spotlight and goes ga-ga. He starts howling at her from his table, his tongue dropping from his mouth like a rolled carpet, eyes bazooka-ing out of his head while Red, all legs and cleavage, struts her little basket around on stage, and what she kept in that basket Grandma had little use for. Hubba-hubba and va-va-va-voom! That's how the wolf was born. ❊ There was a little bit of the wolf in every bachelor. Leaning against a lamppost or strolling down the street with his equally licentious ilk, he took note of any passing pair of nylons. He worked his wolf whistle until he had the virtuosity of Larry Adler; refined his 180 degree turns of longing and desire until he pirouetted like Gene Kelly; perfected his impression of a lost puppy looking for a lap until it was worthy of Frank Gorshin. ❊ The wolf rarely traveled alone. Whistling in harmony with other itchy fellas was more his speed. It helped him bolster his courage, his moxie, his spizzerinctum. The other wolves also consoled him on the rare occasions when the dish delish he made advances to passed by without a glance. "Ah, don't get in a lather, Jackson, she was a dog anyway." ❊ Besides his cronies, the wolf also had his essential accessories. A deck of nudie cards was de rigueur. Not so much for playing poker (the T's and A's made it hard to focus on the Q's and K's) but to share with his friends, showing the pack his pack. And for the most zealously wolfish of wolves, there was the nudie necktie — plain outside, but in the lining was hidden a scantily clad damsel, her negligee negligent, so whenever he wanted he could take a peek and see her looking wistfully up at him and him alone. This is what gave the wolf such a wolfish grin. ❊ Oh my, what big teeth you have.

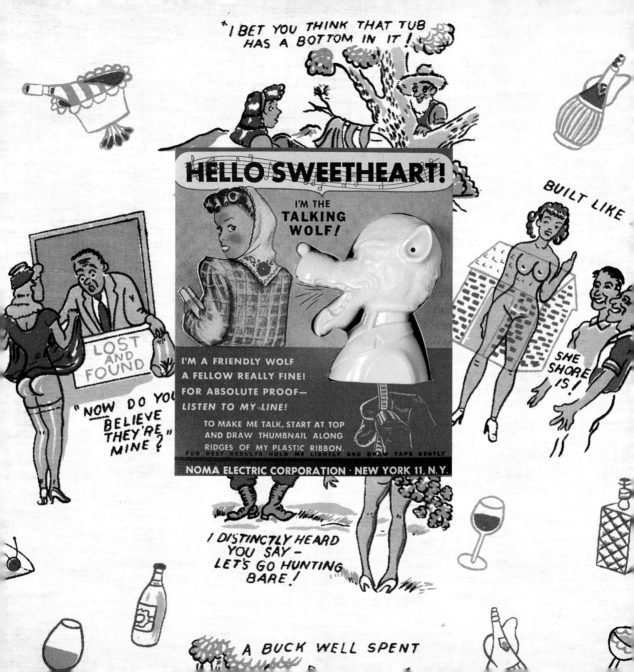

THE

The magazine devoted to pleasure

DUDE

Bachelor

NOV.

3

JANUARY 1956 50

SWANK

Cabaret

THE
PARATROO
WHO TURI

NOVEMBER • 25 CE

ID A SKYE P

SENSATIONAL
EXPOSÉS

FALL 1953 • 35¢

LAFF
annual

200

Escapade

THE
GENT

AN APPROACH TO RELAXATION

APR.
50¢

NUGGET

EYEFUL

lorifying the American Girl

DEC

HIT SHOW

MARCH 35¢

Hi-LiFE

MAY

8 UNCENSORED
ASH PICTURES OF
N UP BEAUTIES

Rogue

FEBRUARY 1961 • 50¢

DESIGNED FOR MEN

MAN

Senior

Registered at the G.P.O., Sydney, for transmission by post as a periodical.

DRIVE

MR

Stare

Opening your first centerfold was taking an oath, swearing allegiance to a life of glorious blasphemy, assuming the mantle of the Musketeer. And each month when you open it again, you renewed your pledge, reasserted your dedication to be covetous, desirous, wanton, to send out beacons on concupiscence in every direction. *Playboy* confirmed the scurrilous in every bachelor while at the same time offered him an array of writers whose stories were on the cutting edge of fiction and whose articles were provocative and insightful.

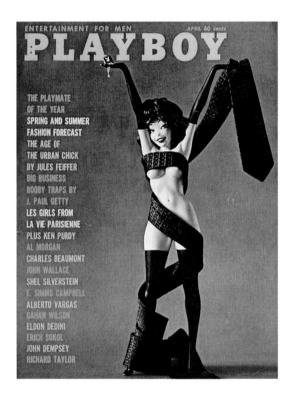

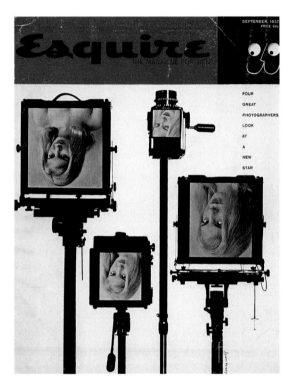

Esquire had everything a bachelor needed except the areolas. Every month it testified to the greater glories of being a hip epicurean and served as a detailed guide to get you there. Oversized, graphically daring, it offered a bachelor everything from advice on sock clocking to which sports car to drive. Ads in the back kept a bachelor in step with the latest clothes and bar supplies. *Esquire* was also on the cutting edge of literature and the arts. And if there was a new French starlet making a splash on the Continent, they were sure to devote a spread to her, showing as much skin as possible.

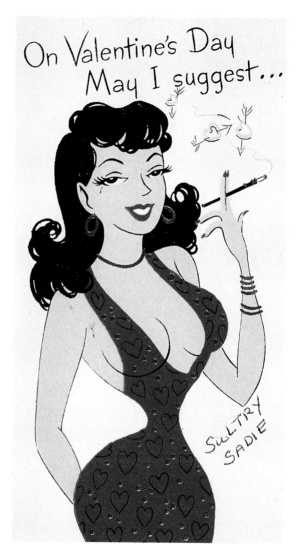

It was hard to keep a good wolf down. Left to his own devices he could be lascivious enough, but with help from the arsenal of accessories available to him, tricks of the wolf trade, he was irrepressible. There was the portable leopard blanket, ready to turn any occasion into a cozy tryst in the jungle, and the Inebriation Computer, "scientifically designed" to keep track of a date's willingness. The wolf call car horn was able to carry his licentious message to any pair of gams strolling on the sidewalk. And most important, in case a wolf found his nocturnal efficiency gone slack, there was a No-Doz in easy reach, guaranteed to keep him up all night.

NATIONAL WOLFING LICENSE

Male and Female

Here is your permit to go **WOLFING.** For those who do not understand this sort of slang we will clarify the meaning of this term. It means an **ABLE GABLE** (a neat bundle of he-man), **A GOOD TIME CHARLIE** (a guy who is working the numbers racket—dating plenty of gals), **FEMALE ROBBER** (date stealer), **NECK-HAPPY** (a spooner); and in other words a **BIG TIME OPERATOR** who looks at anything. Get into the big time and start going after the gals—get your **WOLFING LICENSE.** No one can be a popular operator unless they wear this badge. Two styles: one for MALE WOLVES and one for FEMALE WOLVES. Attractively made of embossed metal. Wear it on your lapel.

No. 2041. **MALE WOLFING LICENSE.** Price Postpaid............. **15c**
No. 2042. **FEMALE WOLFING LICENSE.**
Price Postpaid.. **15c**

Wolf Call Auto Horn

Loud Enough to Scare the Neighborhood!

The Original Hollywood Wolf Call

Never fails to attract attention! Sounds a modern WOLF CALL or makes a noise like a **YELPING DOG.** Sound is loud and natural, yet not too objectionable. Imitate wolf call: dog fight, woo-woo call, etc. **FUNNY, LOUD, TERRIFIC.** It's amazing, interesting and really clears the road! Gives your personality and girl-getting ability a really quick PICK-UP! Woof! Woof!

Loud! Funny! Whooooooo! Whoooooo!

NEW DESIGN—horn trumpet, beaded and styled like trumpets and expensive horns. Brass screen prevents dirt, bugs and dust from entering sound chamber. Two tone, **bright red** trumpet with silver-grey valve unit. Easy to install on all cars, trucks, motorcycles, tractors, gas scooters, motor boats and outboard motors. Uses no electricity, operates from intake manifold.

No. 7638. **WOLF CALL AUTO HORN.**
Price Complete, Postpaid Only.. **$3.98**

Calling all Men...
STRIP-TEASE NECKTIE
THAT GLOWS IN THE DARK

* SHE LOSES HER CLOTHES AS SHE GLOWS IN THE DARK *

Astounding new NECKTIE is the latest rage from coast to coast! Spectacular new novelty tie creation for men who demand the distinctive and unusual! Brings gasps of sheer wonder, thrilling admiration the first time you wear it! By day, smart, handsome tie that is unrivaled for sheer beauty and extravagant good looks, by night a glorious goddess of beauty revealed for all to see. A glorious, gleaming blonde beauty! Fully cut, Well made tie.

No. 4081. Postpaid **$1.49**

TALKING WOLF

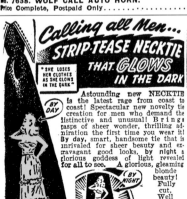

HELLO SWEETHEART

Here is the guy who has all the girls running. **(NOT THE OTHER WAY EITHER) HE TALKS!!!** Yes and with a voice that has more come-on appeal than a beaver-haired crooner. A hot novelty. No self-respecting guy should be caught without one. Regulate speed of the talking from a "fast pitch" to a "slow drawl" and get the fast sassy dames and Southern blondes. Wonderful for bashful fellows who have trouble getting started. (The rest is up to you, brother). Nearly 3-in. plastic head, with talking unit inside. Complete, nothing more needed.

No. 2897. Talking Wolf. Postpaid........ **35c**

Too Pooped To Play, Boy?

When a hard day puts you behind the social eight-ball ⑧, don't drag your heels 🌙 Play it smart ... keep on your toes with NoDoz Tablets.

Take a NoDoz 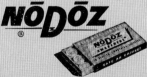 and be ready to concentrate on important subjects

Clinical tests show that for most people NoDoz® increases mental efficiency within minutes 🕐.

Safe as coffee ☕

NŌDŌZ
®

Product of Grove Laboratories, Inc., St. Louis, Mo.

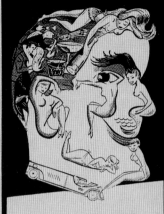

Keep keen when it counts

- When a hard day puts you behind the social eight-ball, don't drag your heels. Play it smart ... keep keen when it counts with NoDoz Tablets.

- Take a NoDoz and be ready to concentrate on important subjects.

- Clinical tests show that for most people NoDoz® increases mental efficiency within 15 minutes. Safe as coffee.

NŌDŌZ
®

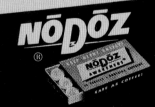

Product of Grove Laboratories, Inc., St. Louis, Missouri

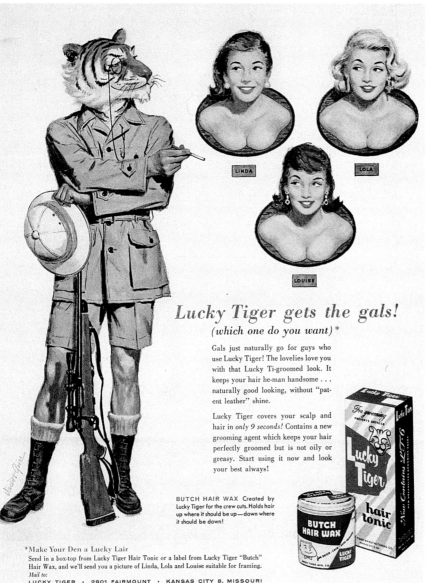

Lucky Tiger gets the gals!
(which one do you want) *

Gals just naturally go for guys who use Lucky Tiger! The lovelies love you with that Lucky Ti-groomed look. It keeps your hair he-man handsome . . . naturally good looking, without "patent leather" shine.

Lucky Tiger covers your scalp and hair in *only 9 seconds!* Contains a new grooming agent which keeps your hair perfectly groomed but is not oily or greasy. Start using it now and look your best always!

BUTCH HAIR WAX Created by Lucky Tiger for the crew cuts. Holds hair up where it should be up—down where it should be down!

*Make Your Den a Lucky Lair
Send in a box-top from Lucky Tiger Hair Tonic or a label from Lucky Tiger "Butch" Hair Wax, and we'll send you a picture of Linda, Lola and Louise suitable for framing.
Mail to:
LUCKY TIGER • 2901 FAIRMOUNT • KANSAS CITY 8, MISSOURI

92 ESQUIRE : September

With names like Take Five and Jade East, aftershaves and lotions conjured up an appropriately wolfish attitude. The wolf used a splash of cologne to announce his entrance into the room, to wolfishly mark his territory, making it easy for the girls to notice him. Why take a chance? Once sensed, your scent will send them. And once sent, they'll be yours for the taking.

THE WILD, WILD WOMEN

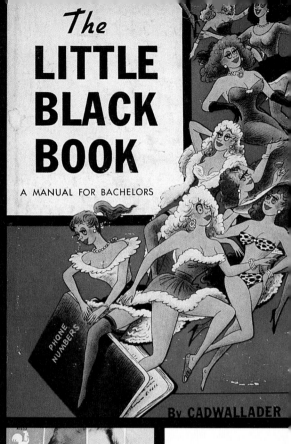

The LITTLE BLACK BOOK

A MANUAL FOR BACHELORS

BY CADWALLADER

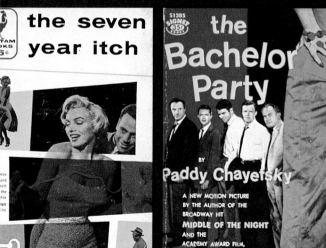

the seven year itch

$1385 SIGNET 35¢

the Bachelor Party

BY Paddy Chayefsky

A NEW MOTION PICTURE BY THE AUTHOR OF THE BROADWAY HIT MIDDLE OF THE NIGHT AND THE ACADEMY AWARD FILM, MARTY

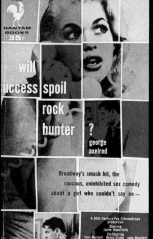

BANTAM BOOKS 35¢

will uccess spoil rock hunter ?

george axelrod

Broadway's smash hit, the raucous, uninhibited sex comedy about a girl who couldn't say no—

A 20th Century-Fox CinemaScope production Starring Jayne Mansfield Co-Starring Tony Randall Betsy Drake Joan Blondell

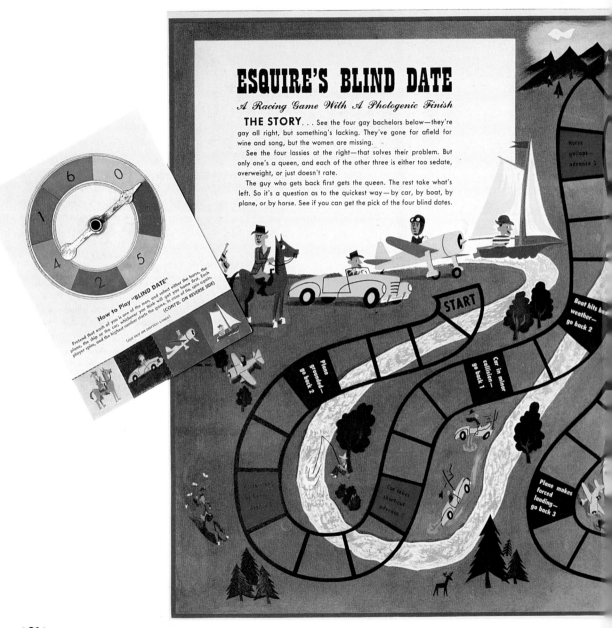

ESQUIRE'S BLIND DATE

A Racing Game With A Photogenic Finish

THE STORY . . . See the four gay bachelors below—they're gay all right, but something's lacking. They've gone far afield for wine and song, but the women are missing.

See the four lassies at the right—that solves their problem. But only one's a queen, and each of the other three is either too sedate, overweight, or just doesn't rate.

The guy who gets back first gets the queen. The rest take what's left. So it's a question as to the quickest way — by car, by boat, by plane, or by horse. See if you can get the pick of the four blind dates.

How to Play "BLIND DATE"

Pretend that each of you is one of the men, and select either the horse, the plane, the ship or the car, whichever you think will get you home first. Each player spins, and the highest number starts the game. In case of tie, spin again.

(CAR OUT ON DOTTED LINES)

(CONTD. ON REVERSE SIDE)

START

Horse gallops— advance 3

Boat hits bad weather— go back 2

Plane grounded— go back 2

Car in minor collision— go back 1

Plane makes forced landing— go back 3

Horse stops to drink advance 3

Car takes shortcut advance 3

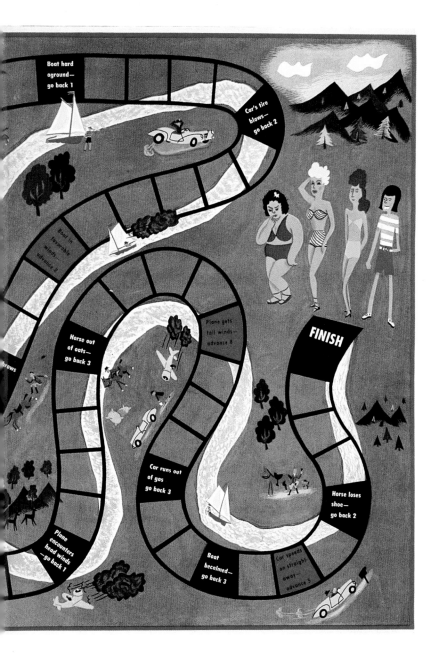

The home version of one of the wolf's favorite pastimes allowed him to keep in shape when something crabbed his act and going on the prowl was impossible, like during monsoons or blizzards. It was also a chance for junior wolves, apprenticing in the wiles of the predatory life, to get accustomed to the vicissitudes of the blind date, especially that most catastrophic snag, getting stuck with a date who was overweight, didn't rate, or just plain out of date. It was also good to get the boys in training early, when they were just cubs. That way there was no chance, later in life, of them displaying even an iota of sensitivity or mistaking a woman for anything but a prize.

Martinis on the house for Jim Biber and Carin Goldberg, Irwin Chusid, Helene Guarnaccia, Adele Hochbaum, J. D. King, Wendy Knox-Leet, Roberto Landauri at the San Francisco Public Library, Mark Newgarden, Tom Nussbaum and Rolla Herman, and an extra round to Bill LeBlond and Sarah Putman at Chronicle Books for their contributions in making this book possible.